SOMETHING COLD AND HARD LIKE WINTER

SHELLEY NIRO

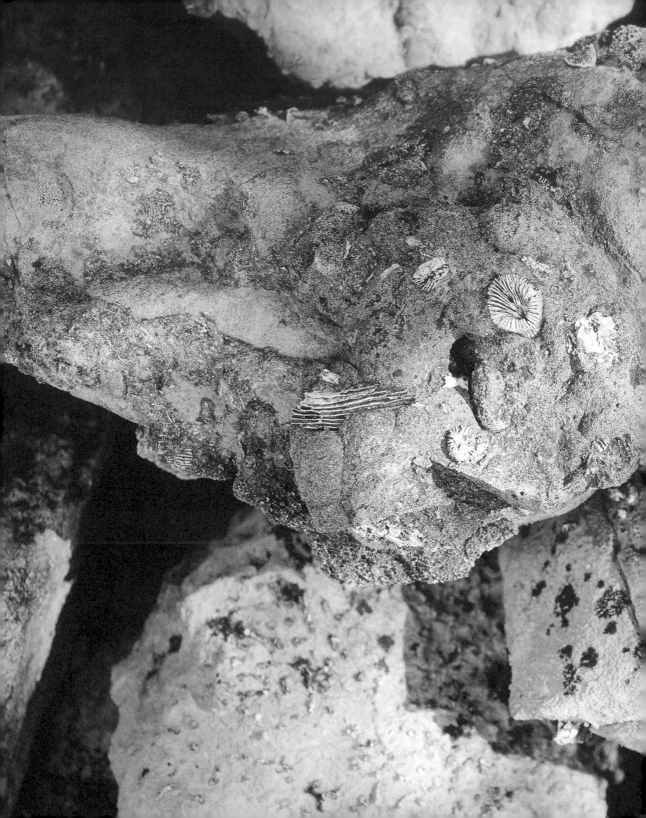

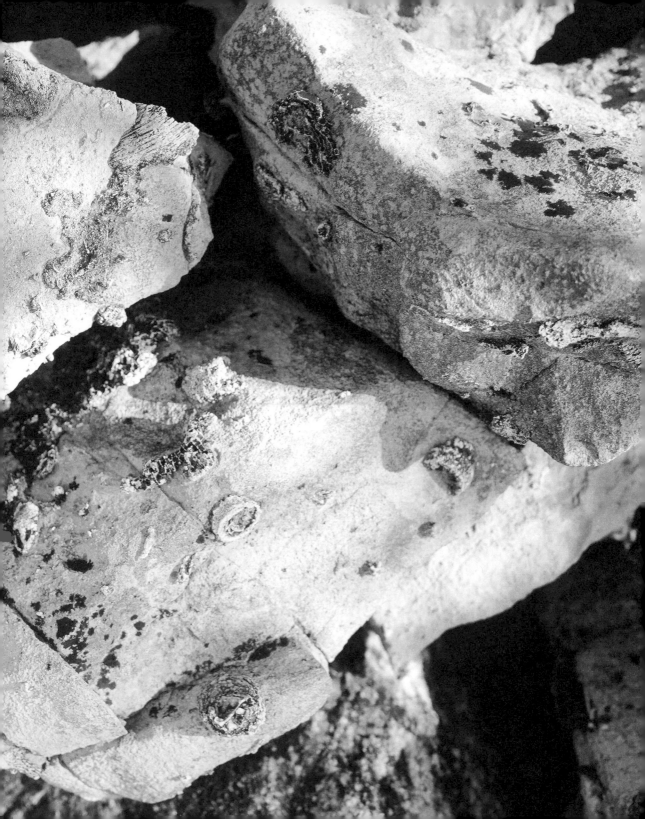

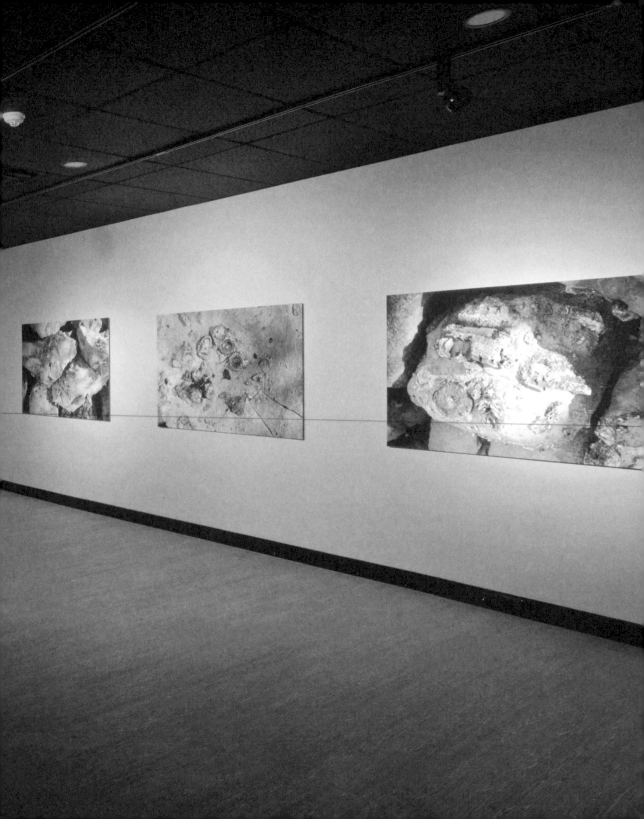

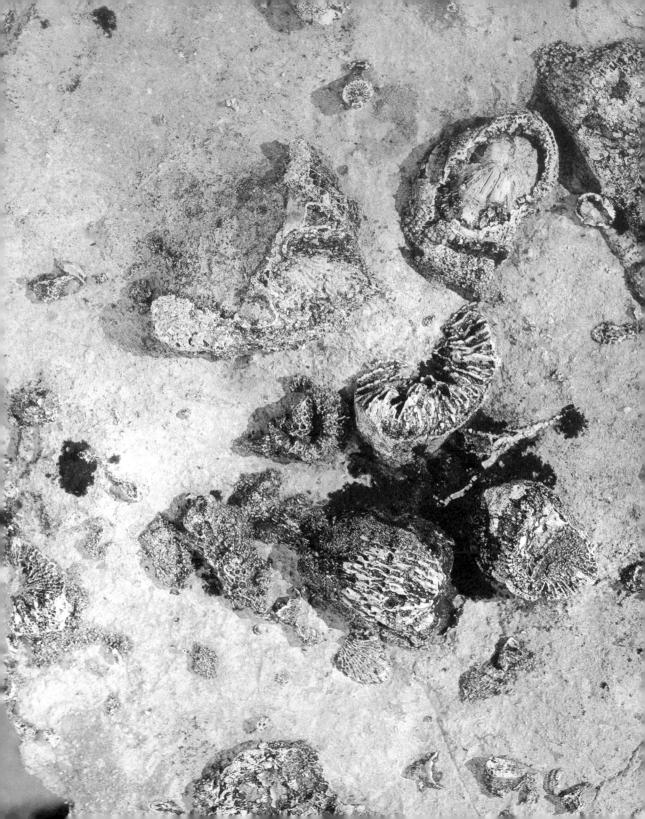

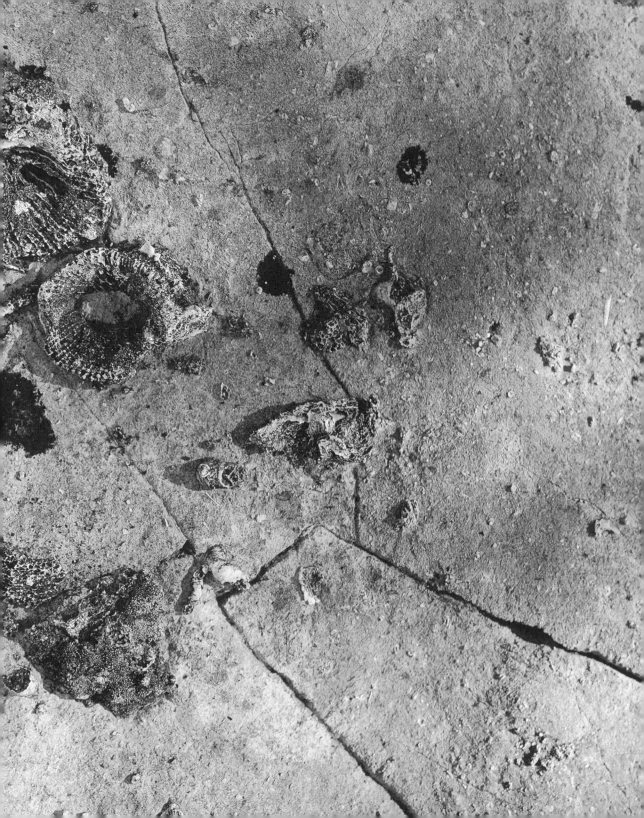

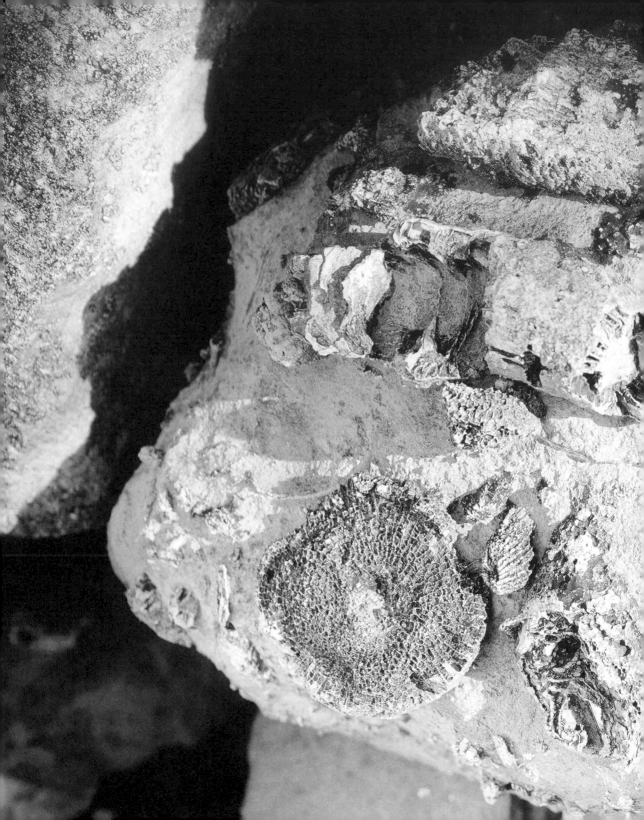

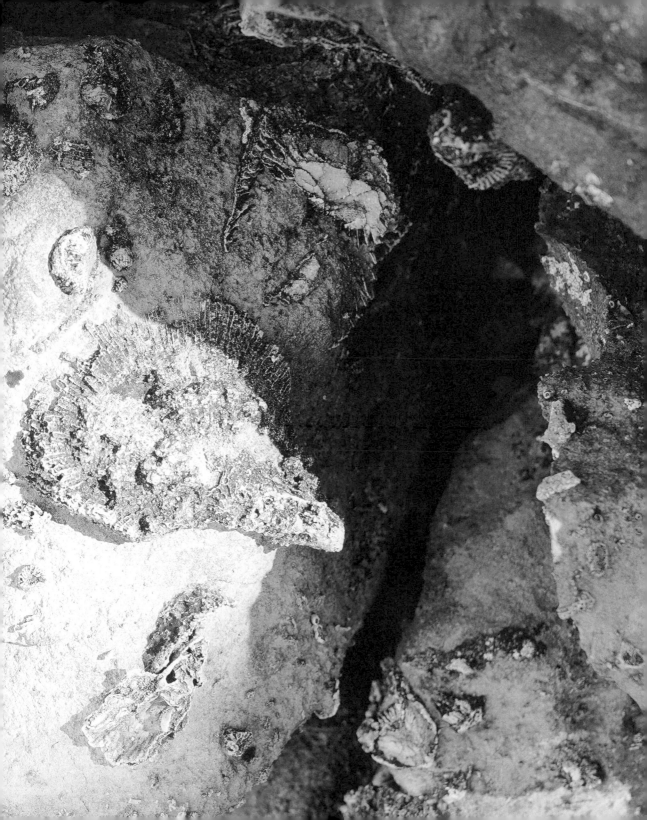

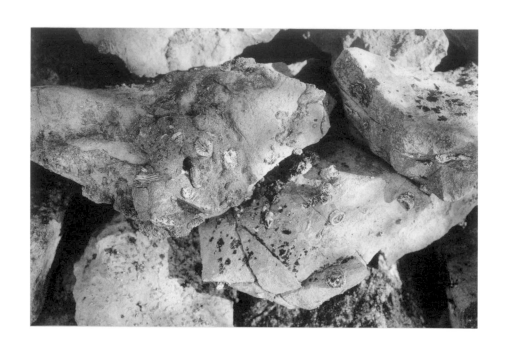

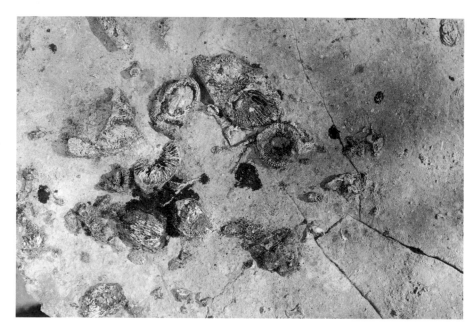

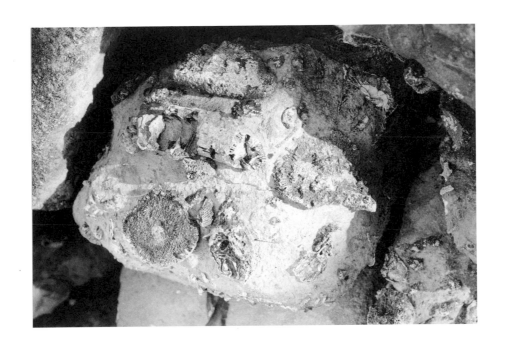

Resting Place of Our Ancestors
(series)
2019
digital print
40" x 60"

FOREWORD

SUZANNE LUKE

I have admired the beauty of black-and-white photography for years. There is something special in the way light and shadow interact with each other and how the tonal range between white and black can generate brilliant boldness or gentle calm. With the absence of colour there is an invitation to slow down, pay closer attention to detail, and linger longer.

In the exhibition *Something Cold and Hard Like Winter*, the omission of colour provides an allure to the images—texture, form, and composition become powerful visual elements. As patrons enter the gallery space, artist Shelley Niro welcomes them with a variety of large-scale black-and-white photographs that showcase the movement of time and the importance of honouring ancestral history. Throughout Niro's art practice we observe a sophisticated entanglement of unique perspectives with traditional Haudenosaunee storytelling. The monochromatic tonal range speaks to the limited and linear ways of past thinking. This results in a shift away from colonial ideology and an awakening to the significance of decolonization to reclaim Indigenous cultural identity, language, and kinship.

In the first series of photographs, *Resting Place of Our Ancestors*, the mysterious rock faces embedded with fossilized remains exemplifies Niro's ongoing exploration of the meaning and longevity of existence. Even as time passes, we must not forget to reflect and honour what came before us; earthly imprints remain, reminding us of our connection to the land.

This examination of anthropological notions continues in *History of the World*. Here, black-and-white images of trees, water, clouds, and rocks are framed within colours used by Indigenous peoples to indicate direction (west-black, north-red, east-yellow, south-white), referencing the directions, the different tribes, and the nations that we come from. Niro goes one step beyond and provocatively superimposes the front and back of the American "Buffalo nickel" (in circulation from 1913 to 1938) on top of the photographs—a direct jab at colonial capitalism and its effects on the environment. The piece showcases the irony of a currency that circulated while Indigenous people and buffalo were brought to the brink of extinction.

The last piece is the only one in full colour. *Peacemaker's Test*, a mesmerizing video installation, invites viewers to experience the majestic beauty and power of the Cohoes Falls. According to Iroquois tradition, this is the sacred place where the Peacemaker was tested by the Mohawks to prove he was the true prophet of peace they had been waiting for. The Peacemaker was placed in a tall tree above the falls and the branch that he sat on was cut, causing him to plummet into the raging waters below. When he emerged unhurt the next day the Mohawks acknowledged he was indeed a prophet of peace and became the first people to join what was to become the Haudenosaunee Confederacy—the strongest union of Indigenous peoples before European invasion.

Something Cold and Hard Like Winter is a well-crafted exhibition that not only speaks to Niro's mastery of visual sovereignty but reawakens viewers to the importance of cultural identity, equality, and unity. Our visual journey began in black and white and closes in full colour, perhaps a reference to the act of seeing. Things are not always as they seem and as an audience are invited to open our eyes to critically examine the details of the historical past, re-evaluate the complexity of the present, and strive for change in the future.

On behalf of the Robert Langen Art Gallery, I would like to express my sincere gratitude to Shelley Niro for her generosity of spirit and unrelenting, unwavering dedication to this publication. A special thanks to author Alicia Elliott for providing a thought-provoking counterpoint that captures the essence of the works in the exhibition. Many thanks to Rob Schlegel and Jennifer Barnes for their generous financial support of this publication. Thank you to Wilfrid Laurier University Press, designer Lara Minja, and photographer Robert McNair for embracing our vision for the publication. The Robert Langen Art Gallery also acknowledges the generous financial support of Laurier Indigenous Initiatives and the Laurier Library.

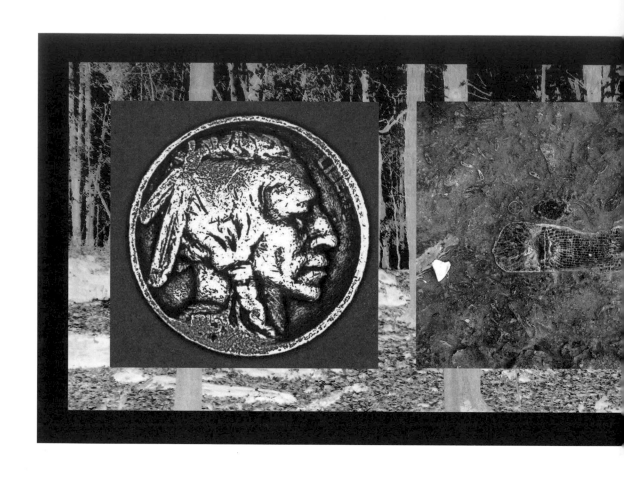

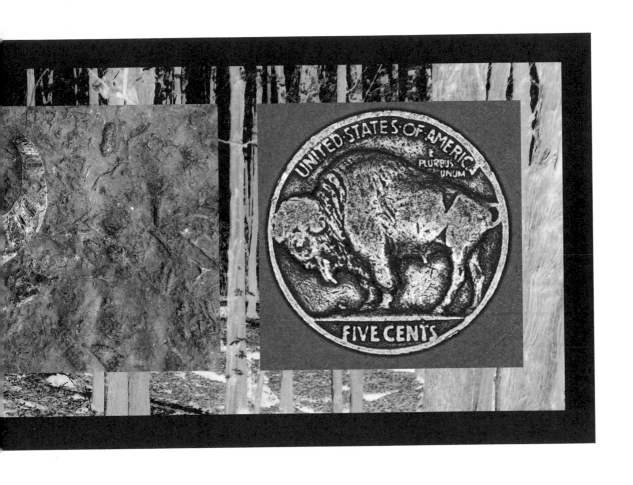

History of the World (West)
2017
digital print
25" x 65"

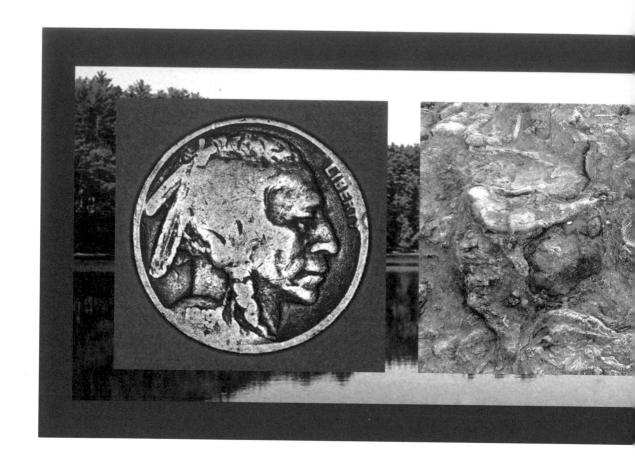

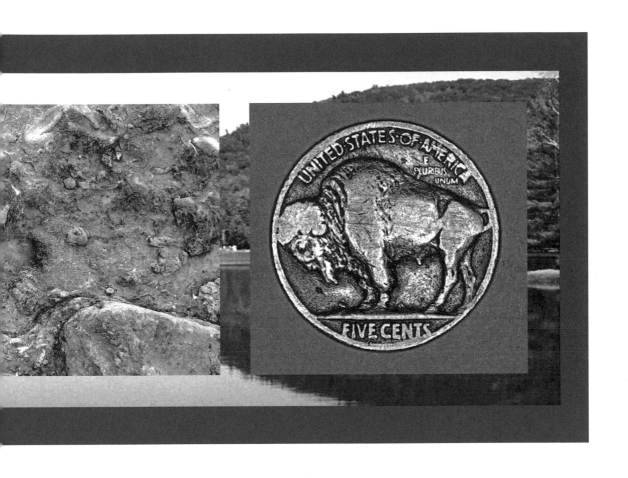

History of the World (North)
2017
digital print
25" x 65"

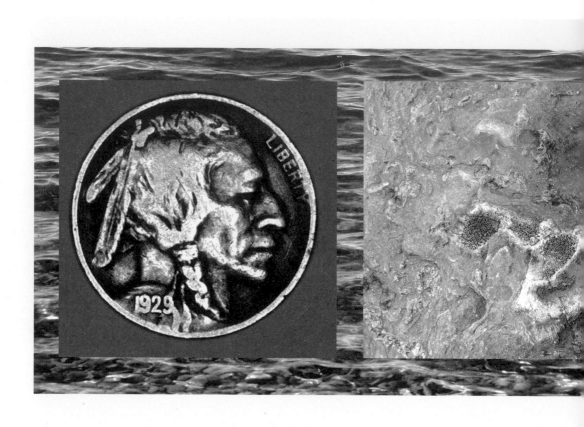

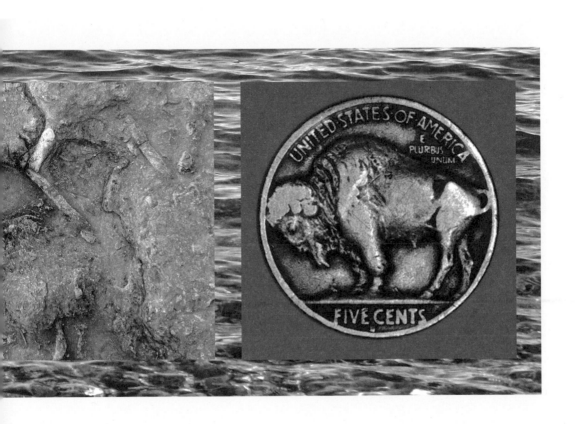

History of the World (East)
2017
digital print
25" x 65"

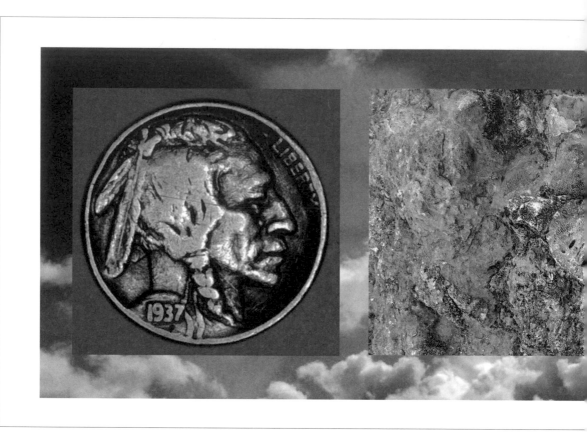

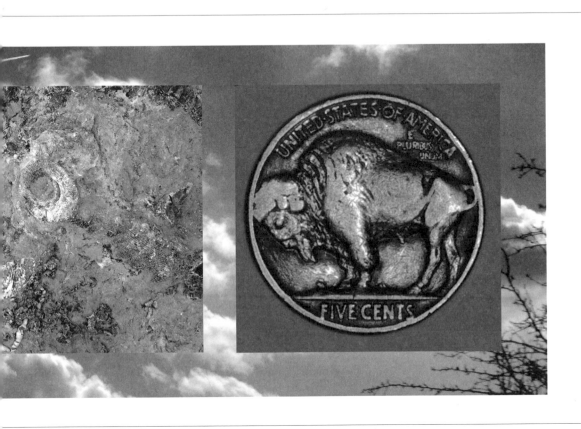

History of the World (South)
2017
digital print
25" x 65"

THE BALM
TO THE BURN

ALICIA ELLIOTT

Recently I've been reading old Haudenosaunee tales of flying heads. These heads are not human-sized. In fact, nothing about them is human. They're monstrous giant heads with sharp fangs and black fur all over, wings protruding from their cheeks. These heads fly on the wind, wild tangles of hair blowing all around them while they search the edge of storms for people to eat. There are some tales of murder victims becoming flying heads, but to me the most terrifying are those humans who turn into flying heads through the act of cannibalism.

As I look at the face on the Buffalo nickel, a composite of at least four different Indigenous men made to please the colonial eye, I can't help but think of flying heads. Not because the Indigenous head is also disembodied, though that's a clear enough connection. No, I'm reminded of flying heads because of what the Buffalo nickel represented—what white representation of Indigeneity always boils down to when that representation is in service of America or Canada or any colonial government searching desperately for culture when all they have is commerce: consumption. The sculptor, James Earl Fraser, was said to be trying to commemorate what he considered to be the dying Indians he observed growing up, along with the dying buffalo: a design he himself referred to as "truly American."

And here we can see it clearly: that cultural and spiritual cannibalism that so defines the Western mentality, which sees everything they encounter as consumable, as profitable, as things they can swallow up and shit out in lesser forms and sell to whoever happens by to make a quick buck. In their hands, our men's faces are dissected and reassembled like Indigenous Frankensteins to become mascots for their money. In their hands, our Plains-dwelling cousins must watch their non-human kin, the buffalo, with whom they have had treaty for centuries, be intentionally hunted into near extinction in a calculated genocidal bid to put to rest the "Indian problem" and make way for Manifest Destiny. In their hands, both our men and the buffalo are pre-emptively made into memorial art, because our images are all that's meant to survive. These flying heads want to eat us and the

buffalo alive, the same way they want to gobble up our mother, the Earth, and her resources, her gifts, her blood. They eat and they eat and they eat and they don't stop. They won't stop.

But that doesn't mean they can't.

For another Haudenosaunee cannibal is known—the man who the Peacemaker was warned about, an Onondaga man with a twisted body and snakes for hair, who ate flesh and cast dark magic, who all tribes feared because he was so ruthless in battle, practically bathing in blood. This man was called Tadodaho. While the Peacemaker had a message of peace, Tadodaho had a message of hate. He murdered Hiawatha's family when Hiawatha even tried to talk to him of peace and following the Peacemaker's path.

And yet. After the Peacemaker survived his test over the waterfalls near Cohoes, proving to the Mohawks that he was the prophet they had hoped for; and after the Mohawks accepted his message of peace; and after the Oneida accepted, then the Cayuga, then the Seneca; and after Hiawatha discovered white and purple shells on the edge of a lake and fashioned them into wampum, realizing that peace—even with the man who murdered his family—was always going to be more important than revenge; after Hiawatha and the Peacemaker came back to Tadodaho to once again ask him to lead the Onondaga and become the fifth arrow in a bundle that couldn't be broken together the way those arrows could be broken alone, Tadodaho allowed the snakes to be combed from his hair. Tadodaho accepted peace, what later became the Great Law.

Like Hiawatha did for Tadodaho, Shelley Niro's art combs the snakes from my hair. Seeing the way she juxtaposes what operate as objects of frustration and handheld racism for me—the Buffalo nickels—with the very elements that make up our experience of our mother—earth, air, fire, and water—in *History of the World* grounds me. For these nickels, though they carry a history rife with pain and war, genocide and cannibalism, they do indeed come from our mother. And like the

Thanksgiving Address, or the words before all else, remind us as Haudenosaunee every time we meet, we must be thankful for every part of creation that allows us to live such beautiful lives, because without them we would have—and be— nothing. This is what unites us, the same way peace united the Haudenosaunee years ago: the miracle of creation.

Shelley Niro's work reminds us that beauty is always apparent, if we remember to look for it. It's just as evident in the sublime terror and awe of the thundering waterfall of *Peacemaker's Test* as it is in the smallest fossils of prehistoric life in *Resting Place of Our Ancestors*—our ancient ancestors' remains making their own sort of art in the stones we pass every day. This work, these realizations, are the balm to the burning cannibalistic commerce we are expected to engage in daily.

This work, these realizations, are how we keep from turning into flying heads ourselves.

ALICIA ELLIOTT is a Mohawk writer from Six Nations of the Grand River territory. Her award-winning first book, *A Mind Spread Out on the Ground*, was a national bestseller. She lives in Brantford, Ontario, with her husband and son.

overleaf
Peacemaker's Test
2020
video (2 min.)
Video Editor: Cher Obediah
Special thanks to Elizabeth Hill
and Shirley Bomberry

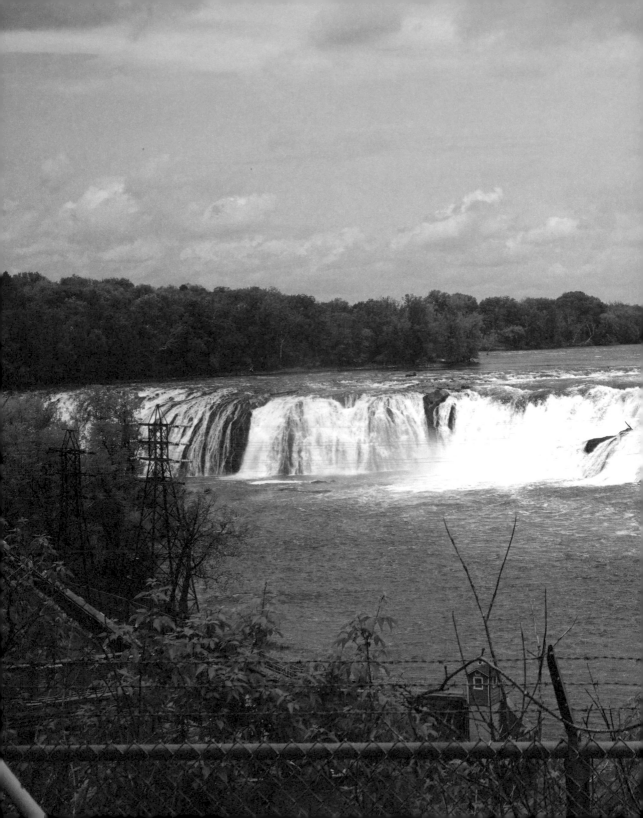

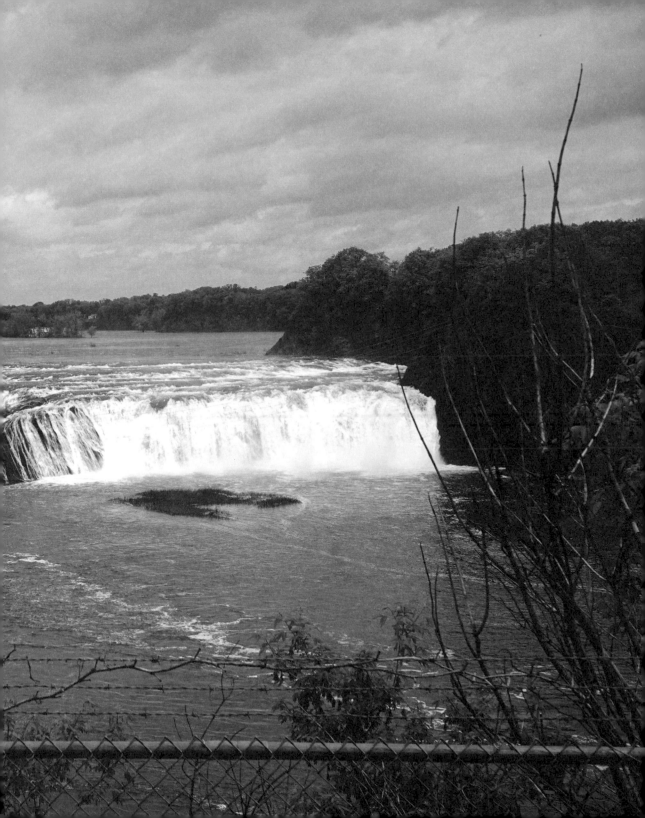

Peacemaker's Test is the sacred place on the edge of a city called the Cohoes.

This is where the Peacemaker was challenged to prove he was the prophet the territories had been waiting for.

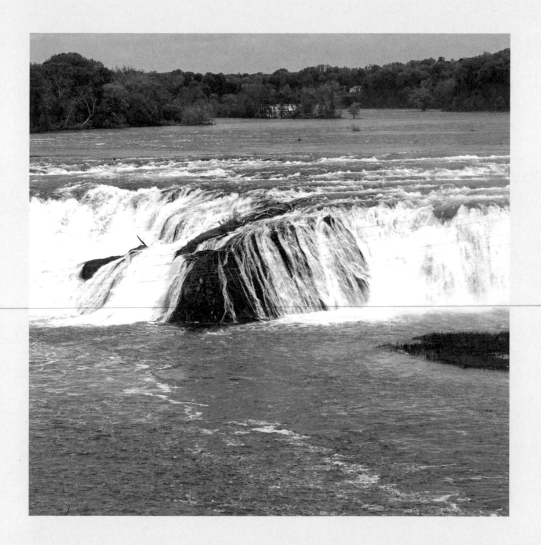

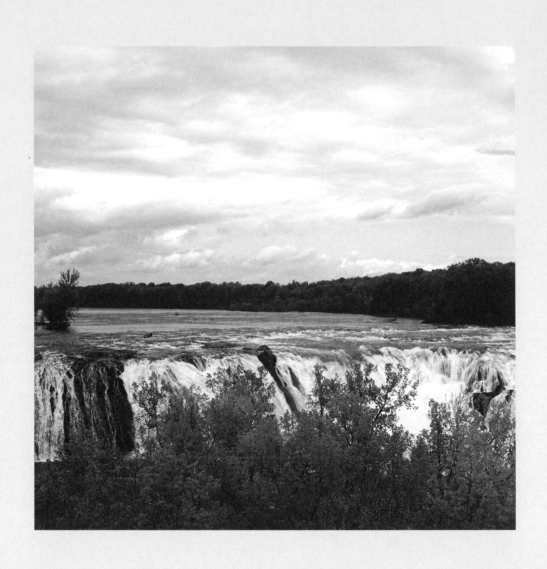

After centuries
of violence amongst the tribes,
he appears, promising peace.

He survives after being thrown
into the waterfalls where the
Mohawk River meets the Hudson.

This is the beginning of the
Iroquois/Haudenausaunee
Confederacy, the strongest union
of Native People before
European invasion.

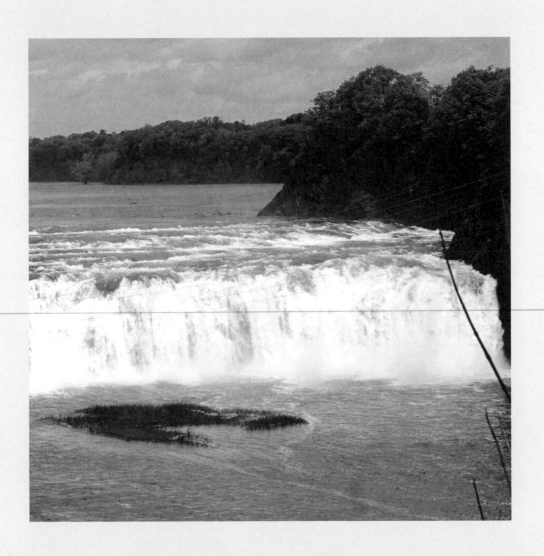

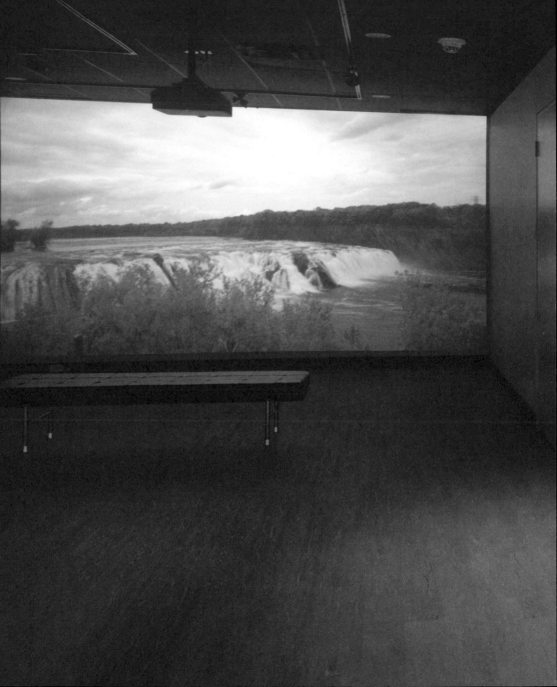

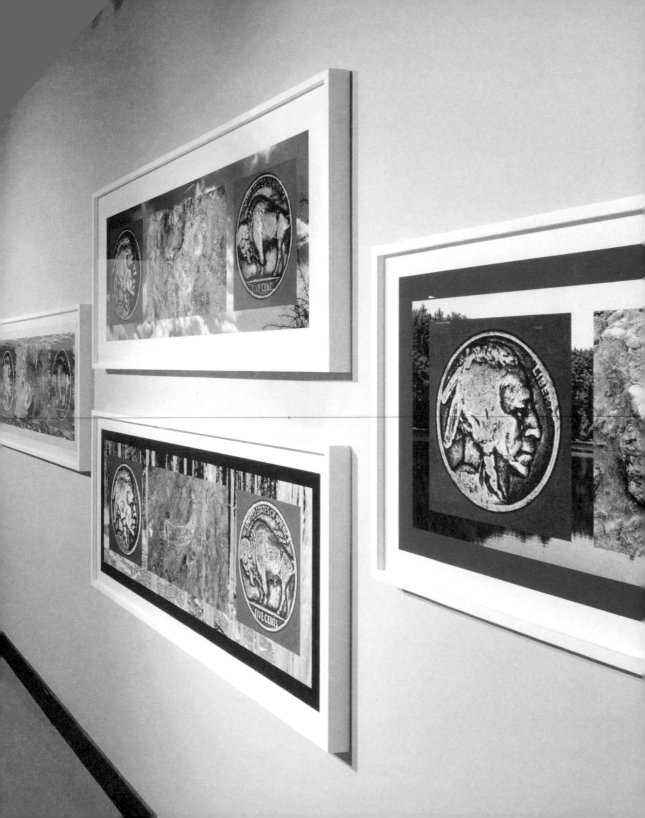

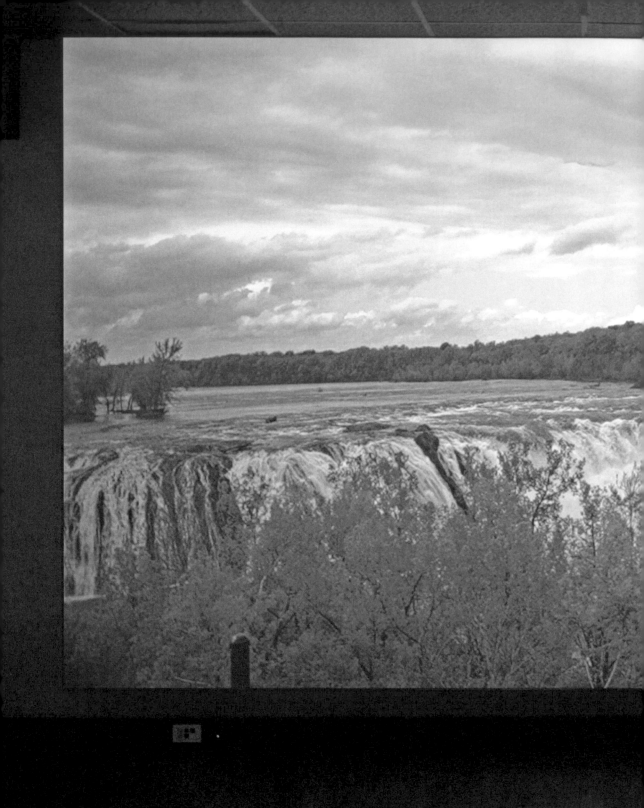

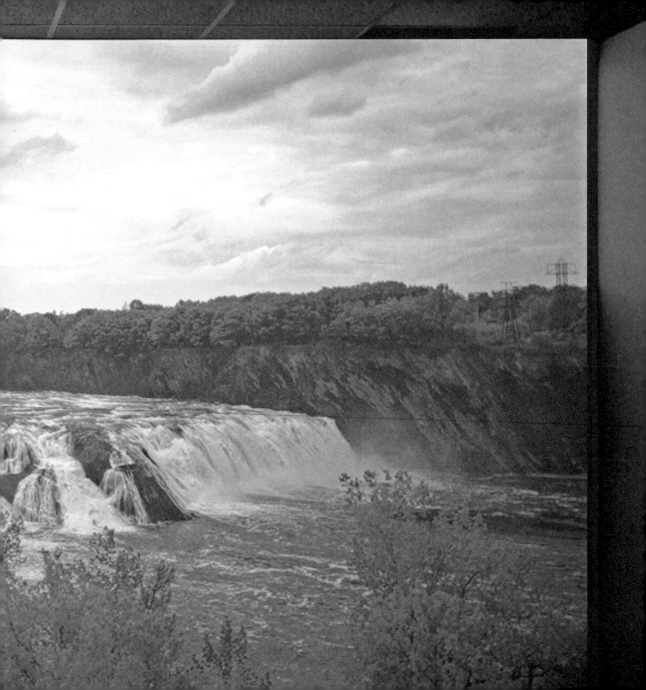

SHELLEY NIRO is a member of the Six Nations Reserve, Bay of Quinte Mohawk, Turtle Clan. Her work spans numerous media and disciplines, including photography, painting, beadwork, and film. Niro is conscious of the impact post-colonial mediums have had on Indigenous people. In photo series such as *Mohawks in Beehives*, *This Land Is Mime Land*, and *M: Stories of Women*, she has worked relentlessly to present Indigenous people in realistic and explorative portrayals. Her films include *Honey Moccasin*, *It Starts with a Whisper*, *The Shirt*, *Kissed by Lightning*, and *Robert's Paintings*. Her most recent film is *The Incredible 25th Year of Mitzi Bearclaw*. She has also produced and directed a short film on E. Pauline Johnson, *Tekahionwake*.

Niro graduated with honours from the Ontario College of Art and received her MFA from the University of Western Ontario. In 2019, she was awarded an honorary doctorate from OCAD University.

Niro was the inaugural recipient of the Aboriginal Arts Award, presented through the Ontario Arts Council in 2012. In 2017 she received the Governor General's Award for the Arts from the Canada Council, the Scotiabank Photography Award, and the Hnatyshyn Foundation REVEAL Award. She is also a Laureate of the Paul de Hueck and Norman Walford Career Achievement Award for Photography.

LIBRARY AND ARCHIVES CANADA CATALOGUING IN PUBLICATION
Title: Something cold and hard like winter / Shelley Niro.
Names: Niro, Shelley, 1954– artist. | Elliott, Alicia, author. | Robert Langen
 Art Gallery, publisher, host institution.
Description: Text by Alicia Elliott. | Catalogue of an art exhibition held
 at the Robert Langen Art Gallery, Laurier Library, Wilfrid Laurier
 University, Waterloo, from February 24 to April 3, 2020.
Identifiers: Canadiana 20210350954 | ISBN 9780994036148 (softcover)
Subjects: LCSH: Niro, Shelley, 1954– —Exhibitions. | LCGFT: Exhibition
 catalogs.
Classification: LCC N6549.N576 A4 2022 | DDC 709.2—dc23

Robert Langen Art Gallery
Wilfrid Laurier University
75 University Avenue West
Waterloo, ON N2L 3C3

CATALOGUE ACKNOWLEDGEMENTS
Suzanne Luke, curator
Alicia Elliott, essay
Murray Tong, editor
Robert McNair, photographer
Lara Minja, graphic designer

Marquis, printer
Printed in Canada

Robert Langen Art Gallery, publisher

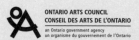
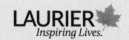
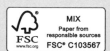